MEET THE
MASTERPIECES

Strategies, Activities, and Posters to Explore Great Works of Art

by Bobbi Chertok, Goody Hirshfeld, and Marilyn Rosh

SCHOLASTIC
PROFESSIONAL BOOKS

NEW YORK • TORONTO • LONDON • AUCKLAND • SYDNEY

To our nine children (three each)
who graciously allowed us to use them to test our art seminars
when they were young, and who have
rewarded us with their love of art now that they are grown ...
and to our husbands, our best friends.

—Bobbi, Goody, and Marilyn

Design by Jacqueline Swensen
Cover design by Vincent Ceci
Illustration by Mona Mark

ISBN 0-590-49212-8

12 11 10 9 8 7 6 5 4 3 4 5/9
Printed in the U.S.A.

CONTENTS

A NOTE TO THE TEACHER

You are about to share with your class the beauty of eight masterpieces of fine art. The paintings will introduce your students to different cultures and allow them to imagine life during other periods of history. The art will excite and surprise them. Best of all, your students will have fun while their appreciation and understanding of art grows.

The paintings and artists included are:

1. *The Peasant Dance* by Pieter Bruegel (BROY-GUL), 1525–1569

2. *Las Meninas* by Diego Velazquez (VEH-LAS-KES), 1599–1660

3. *A Gust of Wind at Ejiri* by Hokusai (HOK-SIGH), 1760–1849

4. *Snap the Whip* by Winslow Homer, 1836–1910

5. *Le Moulin de la Galette* by Pierre Auguste Renoir (REN-WAHR), 1841–1919

6. *The Boating Party* by Mary Cassatt (KA-SAHT), 1844–1926

7. *First Steps* by Pablo Picasso, 1881–1973

8. *The Piano Lesson* by Romare Bearden, 1911–1988

"Action" describes the eight paintings selected for this book. They all show people *doing* things, such as dancing, playing, and boating. Paintings about ordinary people at work or at play are in a category called *genre* art. We have widened the definition of genre to include paintings that portray people in action in a variety of styles. A genre artist tells a story about his or her world and the people who live in it. We invite you and your students to enjoy some time in these eight worlds.

ABOUT THE AUTHORS

With their background as educators and artists, Bobbi Chertok, Goody Hirshfeld, and Marilyn Rosh created Living Art Seminars in 1973 to bring fine art into the classroom, making it fresh, fun, and relevant to each and every child. Through the years, Living Art Seminars has received many state and local grants.

Today, thousands of elementary schoolchildren see, hear, and touch art through 20 different programs designed to stimulate their critical-thinking skills and to impart the message that they are all creative appreciators of art.

The Living Art Seminars approach to art promotes respect and understanding of different cultures. The programs are interdisciplinary, setting the art into historical context, and employing skills of observation, sequencing, speaking, listening, and deductive reasoning.

According to the *New York Times*, "With the help of Living Art Seminars, students are discovering that art is a lot closer and more fun than they had imagined."

GETTING READY

1. Relax. An extensive knowledge of art is not important because the goal of these lessons is simply to enjoy and understand art.

2. There are no wrong answers for you or for your students. The artists who created these paintings broke many rules themselves. We present open-ended questions; divergent responses are encouraged.

 For example, when teaching the first painting, Bruegel's *The Peasant Dance*, you might ask: What are the peasants celebrating? The answer is a feast or fair. It is equally valid for the children to say a holiday or a birthday. They are using their own experiences to relate to the mood of the painting. Those connections are the whole point of the discussion, for they add meaning and richness to the experience of viewing art.

3. Take a good look at each painting *before* you introduce it. Try to remember your own first impressions. Of your five senses, which are stimulated by what you see? Do you have any questions about the painting? Jot them down.

4. Read over the complete section associated with the painting. Try to find a thread that connects the painting with the interests of your students. Make a note of the activities you think will excite them. Now you're ready to begin.

HOW TO USE THIS BOOK

The book is divided into eight sections—one for each of the paintings. A detail from the painting will appear on all of the pages in that section. For example, the dancing peasant is on every page that discusses the Bruegel painting, and you will find the little princess on every page relating to the Velazquez painting *Las Meninas*.

Each section is divided into four parts:

1. MEET THE ARTIST
2. A WALK THROUGH THE PAINTING
3. STUDENT ACTIVITIES
4. LOOKING FURTHER

MEET THE ARTIST

This is a brief biography of the artist that can be reproduced and given to the students. It includes:

 ✦ A picture of the artist.

✦ The place where the artist was born and lived. (You may find it helpful to have maps available.)

✦ A time line placing the artist within a historical context.

Have students save the eight bios in a folder. You may want to have them make books when the lessons are finished.

A WALK THROUGH THE PAINTING

This part is the teacher's guide—and is the highlight of enjoying and understanding the painting. The questions are designed to encourage your students to observe, react, question, imagine, articulate ideas, and express their feelings. Students' responses and your own questions might lead to surprising and fascinating detours.

As you cover each painting, you will want to display the poster of the painting in a prominent place in your classroom. You might want to make a "frame" and hang the paintings in an area where students can gather around them, like a gallery.

This section has two subdivisions:

A. FIRST GLANCE

These questions are open-ended to obtain many responses. They are designed to tap the students' first impressions. Try to encourage children to respond freely—building their confidence and feelings of self-assurance.

B. CLOSER LOOK

The questions and comments in this subdivision give additional information about the period in which the artist lived, the themes of the painting, and the techniques the artist used. Sometimes we explain the title of the painting as well.

Here are some hints for using this section:

✦ Some background information may be helpful to you—but not essential for your students.

✦ For younger students, you might want to present the background information as a story. For example, to introduce *The Peasant Dance*, you might begin: "Once upon a time, long ago when kings ruled the land, there was a little village..."

✦ You may want to relate or compare the painting to real-life situations or to a story that the children have read.

✦ Historical or technical art terms are presented in *italic type* and are defined in context immediately after. These words might be appropriate for spelling and vocabulary activities.

✦ You may wish to lead the discussion in just one session or in two or three short sessions. The response of your class will guide you.

✦ You need not ask all these questions. Just stay with a painting for as long as the students find their visit interesting and relevant.

STUDENT ACTIVITIES

These reproducible pages present creative drawing or writing experiences. They are designed to encourage each student to connect the ideas in the painting to his or her own world.

Here are some hints for using this section:

- ✦ Begin by discussing the instructions with the class.

- ✦ Allow students maximum freedom in interpreting the visual or written response.

- ✦ Some activities may be most valuable for groups, others for individual students. Art is often an excellent vehicle for reaching the exceptional child.

- ✦ After the students complete a page, they may wish to expand the idea on a larger paper.

LOOKING FURTHER

These are suggested curriculum-related activities to extend the learning experience. Most use critical-thinking skills. Some relate to geography and writing.

At the end of the book, there is a listing of suggested culminating activities and a bibliography of children's literature about the artists.

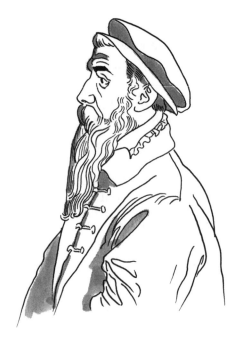

PIETER BRUEGEL

1525–1569

About 35 years after Columbus sailed to America, Pieter Bruegel was born in a small village in the Netherlands. We know very little about his early life. He became a master of a guild in 1551. At that time, all trades and crafts were organized in groups called *guilds*. There were guilds for bakers, weavers, and even for artists.

To become a master, Bruegel probably spent seven years as an *apprentice*. This meant he was a student and an

assistant to a *master* artist. He probably mixed paints, cleaned brushes, and learned to become a painter. Then he had to paint his *masterpiece,* which proved that he had learned all the skills. Now he could start a workshop of his own. But he didn't!

Instead, Bruegel decided to travel to France and Italy. He carried his sketchbook with him everywhere he went. He drew realistic *landscapes* of what he saw—dusty roads, tall mountains, and bustling cities. When he got to Rome, he saw the art of Italian masters such as Michelangelo and Leonardo da Vinci. It was here that Bruegel painted his first religious paintings.

Back in the Netherlands, he often dressed as a farmer and went to the country villages. There, he painted peasants just doing what they do in their everyday lives: sleeping quietly in the field after haying, trudging home across snow-covered hills in winter, and dancing and eating joyfully at their village fairs and weddings.

The wealthy merchants and the leaders of the town loved Bruegel's paintings and bought them. Bruegel married the daughter of his former master, and they had two sons, Pieter, the Younger, and Jan. When both his boys grew up to be artists, the father became known as Pieter Bruegel, the Elder, to distinguish his paintings from those of his son.

Throughout his life, Bruegel painted the peasants who could neither read nor write. He told their story with unusual skill, understanding, and humor.

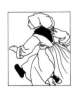

| 1500 | 1600 | 1700 | 1800 | 1900 | 2000 |

THE PEASANT DANCE

ARTIST: Pieter Bruegel **SIZE:** 3'9" x 5'5" **MEDIUM:** Oil on Wood Panel

A WALK THROUGH THE PAINTING

FIRST GLANCE

1. What words would you use to describe the mood of the people in this painting?
2. Name three activities that are taking place.
3. What sounds would you hear if you were at the celebration?

CLOSER LOOK

✦ **Can you guess what kind of celebration is taking place?**
It may be a village fair or a feast day. The people are energetically enjoying themselves.

✦ **Who do you think these people are?**
They are peasants.

✦ **What is a *peasant*?**
Europe was ruled by rich and powerful kings who owned most of the land in the kingdoms. The peasants worked for the king, often as farmers or laborers. In exchange, they received a small hut to live in and a piece of land to grow food on. Peasants had no chance to go to school, and they were very poor.

✦ **Look at the path that leads into the village. Do you notice an object on the ground? What is it and why do you think it is there?**
It might be the handle of a jug that was broken. It suggests that something might have been thrown. It is unexpected and interesting and it leads our eye into the painting.

✦ **Let's meet some of the people who are at the fair. Can you find a lady with a purse and large key? Why do you think she is carrying them?**
Her face, which we see in profile, is very plain. Everything about her seems to be in motion. Her skirts are flying and her feet are moving. We are told by the key and purse that she has something worth locking up.

✦ **Look at the man dancing next to her. Why do you suppose a spoon is stuck in his hat?**
Guests brought their own spoons and knives to a feast (forks were not used yet). Spoons were used to dip into large bowls of food and knives were used for cutting meat. Some historians think the spoon was the *symbol* of a glutton—a person who eats too much. This man's overactive appetite may be the cause of his rotting teeth. The peasants did not eat a balanced diet and there were no dentists.

✦ **Can you locate the only musician at the celebration? What instrument is he playing?**
The unshaven bagpiper is wearing two hats. The bagpipe was made by hand out of animal skin and reeds. It was a popular folk instrument in the Netherlands and was usually played at feasts and weddings.

✦ **Can you find the two children on the left? Why are they dressed as adults?**
There were no baby clothes for peasant children. Almost from the time peasant children could walk, they were expected to work like adults.

✦ **Can you guess why the smaller child has a bell attached to her upper arm?**
The tinkling of the bell would prevent her from getting lost in the crowd.

✦ **Can you find a jester? Why is he at the celebration?**
The jester is near the fence by the tall tree in the middle. He is wearing a bright costume of red and gold, black tights, and a clown's cap. His purpose is to amuse the crowd.

✦ **Why do you think the jester looks so small?**
He is very far away from us. The part of the painting that appears to be farthest from us is the *background*.

✦ **What else is in the background?**

✦ **Look at the bagpiper, the man with the spoon in his hat, and his partner. Why are they so large?**
They appear closest to us. That is the part of the painting called the *foreground*.

✦ **How does Bruegel make our eyes move around the painting?**
Not only are the couples in the painting moving, but Bruegel leads our eyes from one set of figures to the other by using different blocks of color.

✦ **Can you follow the color red?**
It is on the dress of the little girl in the foreground. It jumps to the tunic of the man holding the jug. It darts to the shirt of the man with the spoon in his hat and continues to wind its way through the painting.

✦ **Now can you follow the color black as it makes its way from the foreground to the background?**
It is like a ribbon that pulls our eyes from place to place.

✦ **Can you find the inn, which is decorated with a large banner?**
Every village would have an inn where a traveler could spend the night and the local people could come for food and drink.

Name _____

BRUEGEL'S ALPHABET

Pieter Bruegel made these drawings of the everyday lives of the peasants. Inside the empty letter blocks, draw an object that wasn't invented at the time that Bruegel lived. Example: A – Air conditioner, B – Bus, C – Camera.

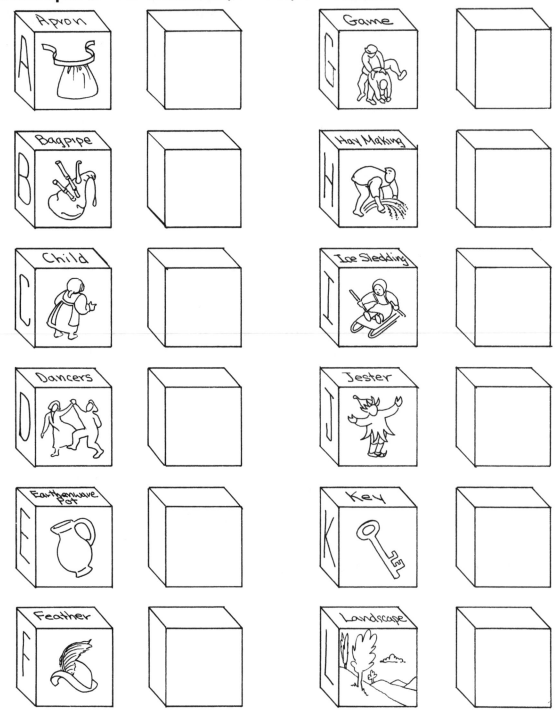

Name _____

BRUEGEL'S ALPHABET

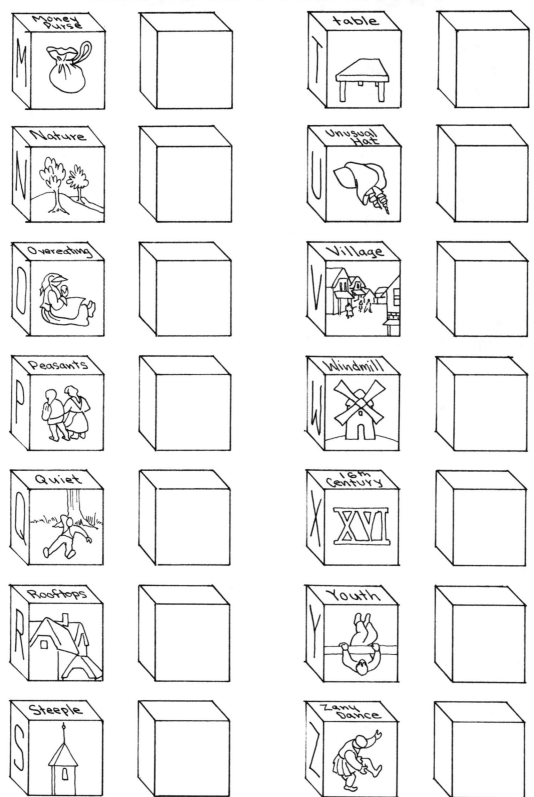

13

TRADING PLACES

There is a banner over the inn in Bruegel's *The Peasant Dance.* Since most peasants could not read, inns and shops used pictures to show what was sold inside. Can you guess what kinds of shops would display these four signs? Write your answers below.

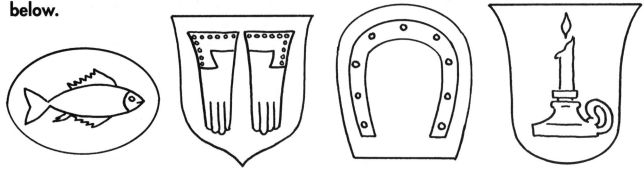

_____ _____ _____ _____

In the shape below, create your own trade sign. This is a kind of advertisement, so make your sign attractive enough to bring people into your shop. See if the class can guess what you are selling.

LOOKING FURTHER

1. Have the students imagine they have been invited to *The Peasant Dance*. Suggest that they write a story or poem about one of the people at the fair. They can describe the person and see if the class can guess who it is.

2. Find some other peasant paintings by Pieter Bruegel. Have the students compare them to *The Peasant Dance*. If you can find photographs of an old section of a Dutch town today, students could also compare these buildings with those in Bruegel's painting.

3. A peasant's life depended upon the land and the seasons. Divide the class into four groups representing the seasons. Research the activities that took place during the seasons. Each group can make a large mural of that time of year. Have them include people doing many different activities. The background of the mural will be a landscape that tells about the season.

4. Pieter Bruegel illustrated popular Bible stories and myths. He dressed the people in the paintings in the clothing of his time. Have the students illustrate a well-known children's story or myth, in modern dress. For example, Peter Pan wears jeans and a baseball cap.

5. Pieter Bruegel traveled from Brussels, Belgium, to Lyons, France, to Calabria, Sicily, Naples, and Rome (all in Italy). How do you think he traveled? What were the roads like? If he moved quickly, he probably traveled 20 miles a day. On a map, have the students locate these places. They can look at the scale and measure the number of miles between the stops. A real challenge would be to have the students trace his journey and try to figure out how many days it took him.

6. After your students have looked at Bruegel's alphabet and illustrated their own modern alphabet, they may want to write a story or a play about what life was like without the 26 modern objects.

7. In 1559, Pieter Bruegel made a painting called *Netherland Proverbs* where he illustrated the proverbs popular in his day. Proverbs, or sayings, such as "A bird in the hand is worth two in the bush" or "A stitch in time saves nine" encouraged people to work hard and behave. Below is a proverb we use today. Copy it on the board and see if your class can guess what it means. Then have them try writing their own proverbs. Suggest that they illustrate one and see if the class can guess what it means.

| Look | be- | fore | you | leap |

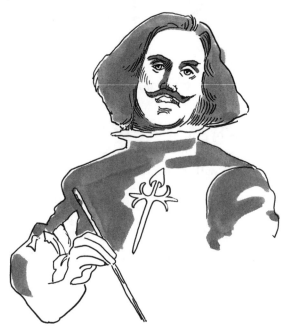

DIEGO VELAZQUEZ

1599–1660

In America, some children dream of becoming president. Three hundred years ago in Seville, Spain, a young boy dreamed of becoming painter to the king. The boy was Diego Velazquez, and his dream came true!

Velazquez's parents were quite well-to-do. They recognized Velazquez's artistic talent and let him become an *apprentice* when he was only 11 years old. Velazquez went to live with the artist-teacher Francesco

Pacheco and study in his busy workshop. There, he was trained in art, as well as literature, philosophy, anatomy, mathematics, and the Bible. Pacheco was pleased with his student. And when Velazquez became an independent artist, he married Pacheco's daughter.

In 1623, Velazquez traveled to Madrid, Spain's capital city. He was introduced to the 19-year-old Spanish king, Philip IV. The king and the artist came to like and respect each other. They had many things in common. They were both young, they both loved art, and they both were quiet and dignified men.

Philip appointed Velazquez to the royal household. From this time on, he and his family lived in comfort in the palace. He spent his days painting *portraits* of the king, the royal family, and their attendants and pets.

Twice Velazquez traveled to Venice and Rome. The first time, he studied the art of the great Italian painters Titian, Raphael, and Michelangelo. On his second trip, he bought paintings to decorate the palace and also painted a portrait of the Pope.

Velazquez was able to make the objects in his paintings look realistic. He painted events as though they were taking place right in front of you. His great masterpiece was *Las Meninas*, which means *The Maids of Honor*. He painted it four years before his death.

1500 1600 1700 1800 1900 2000

LAS MENINAS

ARTIST: Diego Velazquez **SIZE:** 10'5" x 9' **MEDIUM:** Oil on Canvas

A WALK THROUGH THE PAINTING

FIRST GLANCE

1. Do you think this painting was done a long time ago or today? How can you tell?

2. How many figures can you find in the painting?

3. Look at the painting for a moment. Now close your eyes. Which figure in the painting do you remember best? Why?

CLOSER LOOK

✦ In *Las Meninas*, we have been invited into the Royal Palace of King Philip IV of Spain. Philip was king almost 400 years ago.

✦ **Can you find the artist, Diego Velazquez? What clues help us identify him?**
He stands behind a large easel. In his left hand he is holding a *palette,* a thin oval board on which paints are mixed. In his right hand he is holding a long-handled paint brush.

✦ **What is a *self-portrait?***
If an artist paints a picture of himself, it is called a *self-portrait.* In *Las Meninas,* Velazquez has painted himself painting a picture.

✦ **Where is Velazquez painting?**
This is not an ordinary room in an ordinary house. It is a room in the palace. In this studio, Velazquez lived and worked and produced many paintings of the royal family.

✦ **What are some of the ways the artist has shown us the size of the room? Can you find the vertical lines of the canvas on the easel? Can you find vertical lines on the window on the right?**
Vertical lines make our eyes move upward. The room looks large because huge paintings hang on the back wall. Patches of light that begin in the *foreground* and move back to the lighted doorway give us a sense of great depth and space.

✦ **Which figure did Velazquez place in the center of his picture?**
The five-year-old Princess Margarita is the center of attention. Her golden hair and fancy dress are bathed in light while the other figures are much more in shadow.

✦ **On either side of the little princess are the two maids of honor. Can you guess what their duties were?**
The maids of honor were selected to serve the princess and live in the palace. On the right is

Dona Isabel, who is about to curtsy. Dona Maria, on the left, is offering Margarita a drink of water from a small pitcher on a tray.

✦ **Can you find the dwarfs on the right side of the painting? Can you imagine why dwarfs lived in the palace?**
While everyone else in the palace was expected to act seriously and in a dignified manner, the dwarfs were there to provide amusement. Many of them were brought to the palace when they were very young and often became the companions of the royal children.

✦ **There are five other people still to be identified in the painting. Can you find them?**
In the *middleground*, the area between the foreground and the background, are two servants having a conversation. In the lit doorway, an elegant man stands on a staircase. Although everyone else in the painting is known by name, the identity of this man is not certain. *Who do you think he might be?*

✦ **Where are the other two people?**
King Philip IV and young Queen Marianna, the parents of Princess Margarita, are reflected in the mirror on the back wall.

✦ **If this is their reflection in the mirror, where are the king and queen standing?**
They are standing in front of Velazquez—exactly where we are. Just like the king and queen, we are watching Velazquez as he paints.

✦ **If you could walk into the painting and peek at the canvas in front of Velazquez, what do you think you would see on it?**
There are many possibilities. He might be painting the Princess Margarita. Or he might be painting portraits of the king and queen. Certainly, he might be painting the picture we are looking at now—his studio and all the people in it. Much of the excitement and mystery of the painting comes because we will never know the answer.

✦ **Velazquez never titled his painting. After he died, it became known as *Las Meninas*, which is Spanish for *The Maids of Honor*. What title would you have given it?**

Note: For the following activity, Who Am I?, the identifications are: Princess Margarita, 1; Velazquez, 4; maids of honor, 2, 3; servants, 8, 9; royal pet, 5; Queen Marianna, 11; King Philip, 12; dwarfs, 6, 7; visitor, 10; dog teaser, 7; in mirror, 11, 12; looked at by Velazquez, 11, 12, and/or the viewer.

WHO AM I?

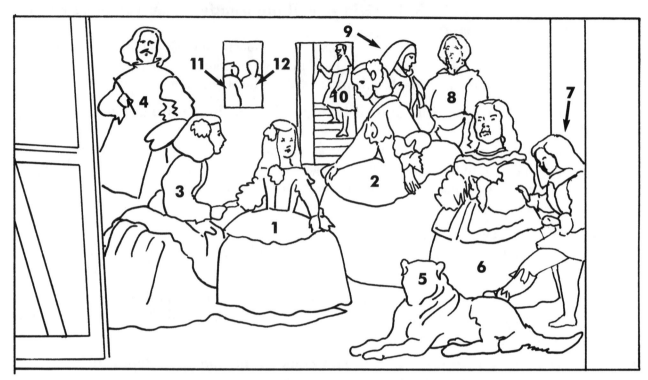

Velazquez painted 12 figures in *Las Meninas*. Each figure has a number. Can you guess who each one is? Put the appropriate number on the line next to the question. Then color the picture.

I am the Princess Margarita. _____

I am the artist, Diego Velazquez. _____

We are the maids of honor (las meninas). _____ _____

We are the servants. _____ _____

I am the royal pet. _____

I am Queen Marianna, Margarita's mother. _____

I am King Philip, Margarita's father. _____

We are the dwarfs who amuse the princess. _____ _____

I am a visitor to the palace. _____

Who is teasing the dog? _____

Which figures do we see reflected in the mirror? _____ _____

Who is Velazquez looking at? _____ _____

Name _____

IF PAINTINGS COULD TALK

I am Princess Margarita and I am five years old. I live in a huge palace with 1,000 servants who take care of me. My servants are always fussing over me. At breakfast, one cuts my food while another holds my napkin. Then my maids of honor dress me. This takes most of the day. My clothes are so stiff and heavy, they could probably stand by themselves. I have to go through the door sideways because my skirts are so wide. I would love to run and play, but I have to behave like a future queen. The most important subject I am taught is etiquette, the rules of behavior. I must not laugh too loud or walk too fast. I have to learn how to greet important people and make polite conversation. I have no friends of my own age and sometimes I am very lonely.

If Velazquez or the dog could talk, what would they tell us about their lives? Write your answer in each space.

PUT YOURSELF IN THE PAINTING

Many artists admired *Las Meninas*. They copied Velazquez's workshop in the palace, and placed their own family and friends in the paintings. Draw your family in this picture. Decide who will be the artist. Who will stand in the doorway? Who will be reflected in the mirror?

LOOKING FURTHER

1. Velazquez's people look so real. Can your class imagine what they might be saying to one another? Have them write a little play about this scene. Perhaps they would like to name each character and write the dialogue. They might want to act out the scene.

2. Your students may want to work in small groups and make a diorama of this scene. They could cover the walls with material and hang paintings on the back wall. They could make the figures from pipe cleaners or cardboard and dress them.

3. Perhaps students could find another painting by Velazquez in a book in the library. Is it also of the royal family? Before Velazquez lived in the palace, he painted everyday scenes of ordinary people. Have the students compare and contrast the paintings they find to *Las Meninas*.

4. Find a map showing the world in the 1500's. If possible, distribute copies to your students. They can find and color in Spain, as well as the other parts of the world that were governed by Spain at that time. They may be surprised to find out that Spain ruled the Netherlands, Hungary, Austria, and Italy.

5. The rules of etiquette or behavior were very strict long ago, especially in royal courts. But even today, we have rules of good manners and behavior. Discuss with your class the rules that they think are important. Have them make lists and share them with each other.

6. Velazquez painted a self-portrait in his larger painting. How do the children think he was able to do it? Have them look at their reflection in a mirror and sketch their own self-portrait.

7. After reading about Princess Margarita, ask the students if they would like to make a flip book or a comic strip about a day in the palace.

8. Pablo Picasso and Salvador Dali, two 20th-century artists, painted their versions of *Las Meninas*. Can you find copies of these paintings? How are they different from Velazquez's original?

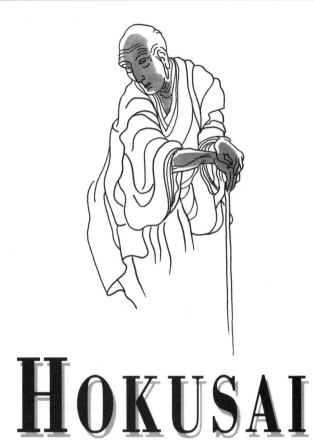

HOKUSAI

1760–1849

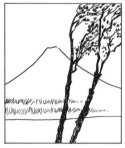

The Japanese artist Hokusai was always on the move. He painted so quickly that he created 30,000 paintings during his life. That was nearly two paintings a day!

Hokusai came from a poor family in the countryside. He started working when he was very young. To find work, he moved to the bustling town of Edo—today's Tokyo.

Hokusai worked for an artist named Shunsho, who made woodblock prints. These prints showed people in everyday

life and sold for a penny or two. Hokusai was so good that he was allowed to take part of his teacher's name and call himself Shunro. This was one of the 30 names he used throughout his life.

Hokusai had to move 93 times because he couldn't afford to pay the rent. But he sketched constantly. He painted fishermen and wrestlers, women washing rice, mischievous children, and a magician rising out of a vase. He painted birds and plants as carefully as a scientist. He also designed beautiful one-of-a-kind greeting cards called *surimono*.

He once painted two birds on a single grain of rice. He even made a painting so huge that it could only be viewed from the rooftops.

When he was 70 years old, Hokusai painted *36 Views of Mt. Fuji*. These were *landscapes* of Japan's most famous mountain. He showed how one thing can be seen many different ways. The artists of Europe thought that Hokusai's prints were the art of a master.

Toward the end of Hokusai's life, he signed his paintings "An old man mad about art." This was the last of his many names.

1500 1600 1700 1800 1900 2000

A Gust of Wind at Ejiri

ARTIST: Hokusai **SIZE:** 9' ⅝" x 14' ¾" **MEDIUM:** Woodblock Print

A Walk Through the Painting

First Glance

1. **Look at how the people are dressed. Can you guess the country where they live?**

2. **Can you guess what crop is growing in the fields?**
 It is the most important crop in Japan—rice.

3. **What words would you use to describe the weather?**

Closer Look

✦ **How did Hokusai show the force of the wind? What is moving?**
A man has lost his hat and it can be seen flying away to the right. Sheets of paper are blowing in the air. Leaves are dancing in the wind and the tree is bent from the force of the wind. The people's bodies are also bent to protect themselves from the strong gusts.

✦ **What is not moving?**
In the background rises the mighty Mt. Fuji, which has always been sacred to the Japanese people. It is the highest and most admired mountain in Japan. It is also a sleeping volcano. It forms a perfectly shaped cone that artists and poets love to describe. Its stillness is a contrast to everything else that is moving. *A Gust of Wind at Ejiri* is one of a series of woodblock prints titled *36 Views of Mt. Fuji*. This print is one of the 36 views.

✦ **The mountain and the wind are two forces of nature. The Japanese worshipped nature and respected its power and beauty.**

✦ **How did Hokusai show the shape of Mt. Fuji?**
Japanese artists often use a simple outline to indicate shape and form. Hokusai used one continuous line.

✦ **Can you follow the path of the raised highway?**
The highway makes an S shape. It is the long, winding Tokaido Road, built to link Tokyo and Kyoto. In ancient times, the Japanese emperor lived in Kyoto and the *shoguns* (military leaders) were stationed in Edo (Tokyo). The Tokaido Road joined the two cities and was known then as the busiest highway in the world.

✦ **Can you find a little hut on stilts in the middle of the print?**
It is too small to be a house—it probably was a shrine where travelers could rest and worship the beauty of nature.

✦ **Can you find the traveler who is losing the sheets of paper?**

She is the one female traveler on the extreme left of the print. Her kimono is blown over her head.

✦ **What do you think is written on those papers?**

✦ **How did some of the travelers carry their belongings?**

Most travelers on foot tied a straw bag to the end of a bamboo pole. Then the pole was thrown over the shoulder.

✦ **Are there any shadows in this painting?**

No. Like many other Japanese artists, Hokusai was not interested in surface effects of light and shade and did not paint shadows.

✦ **Can you find where the artist signed his name and titled his print?**

In Japan, the artist has a stamp or seal made with his name. Hokusai's seal is at the lower right. In the left rectangle is the title *36 Views of Mt Fuji: Ejiri in Suruga Province.* Ejiri is where Hokusai saw this view of Mt. Fuji. Next to that, Hokusai has written: "Done by Iitsu, the former Hokusai." As he had often done, Hokusai took a new name, Iitsu.

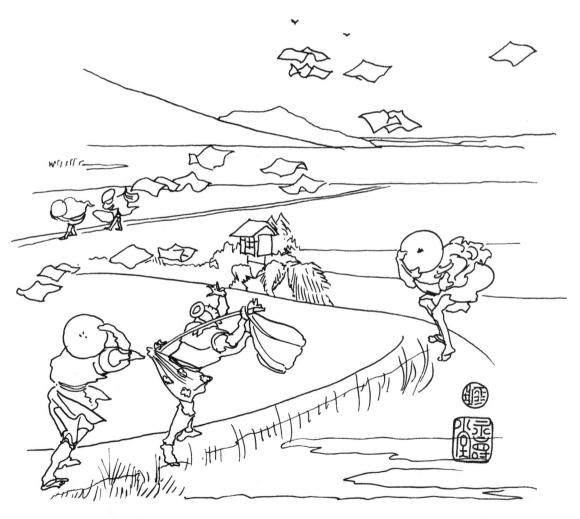

Name _____

DECORATE A KIMONO

Hiroko and Hiroki are wearing their kimonos. Hiroko's is tied with an *obi*, a wide sash. Hiroki's kimono is tied with a simple string. With your crayons, decorate the children's kimonos.

HIROKO

HIROKI

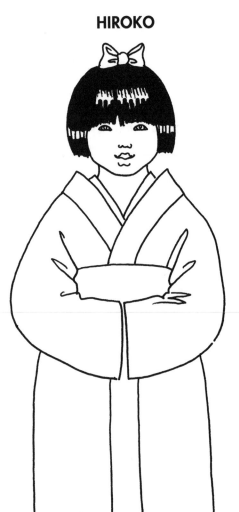

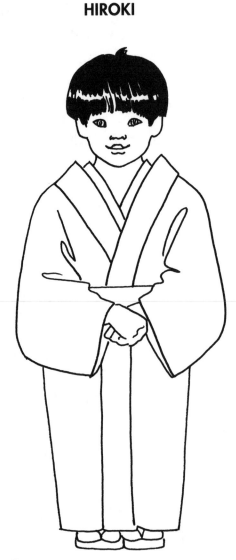

Hiroko's kimono might be decorated with flowers, butterflies, or other symbols of nature.

Hiroki's kimono might be decorated with a *crest*, which is a symbol of his family. You might want to design your own crest.

Name _____

JAPANESE MYTH

 Susano-o was the violent and angry god of wind and rain. He loved to tease his sister, the kind and beautiful sun goddess, Amatera-su. He flooded the rice fields she had carefully warmed with her rays. In despair, Amatera-su hid in a cave and the world became dark and cold.

 The other gods were very angry. They had to find a way to bring back the light. They gathered some stars from the sky and made a mirror which they hung on the branch of a tree outside the cave. Above the mirror they placed a string of precious jewels. Then, the gods sang and danced on wooden boards, making a very loud noise.

 The sun goddess was curious and peeked out of the cave. First, she saw the shining jewels. Then she saw herself in the mirror, but she did not know who it was. As she came closer, the gods seized her and would not let her return to the cave.

 Susano-o was sorry he had caused so much trouble. He killed an eight-headed dragon and found a sword in its tail. He gave the sword to his sister.

 The sun goddess sent her grandson to rule the islands of Japan. He took with him three treasures: a sword, the jewels, and the mirror. According to legend, all the emperors of Japan are descended from the sun goddess. The sword, jewels, and mirror are symbols of their power.

Now color these finger puppets and cut them out on the dotted lines. You can fasten the tabs with tape. When you're done, act out the story of Amatera-su and her brother, Susano-o.

LOOKING FURTHER

1. Japanese artists love to make scrolls that show the beauty of nature. Tell students to close their eyes and picture a single flower, a mountain surrounded by clouds, or some other lovely place or moment. You might read a poem. Now they are ready to begin.

Materials Needed

- ✦ 6"x 18" sheet of paper
- ✦ red ribbon or yarn
- ✦ glue
- ✦ crayons, magic markers, or paint and brush
- ✦ patterned wallpaper
- ✦ hole punch

Hold the paper vertically and have the children draw or paint on it. Glue strips of wallpaper on the edges to make a border. Punch holes on either side near the top. Fasten yarn or ribbon so that the scroll can be hung.

2. Your scroll might inspire your students to create a *haiku*, a traditional form of Japanese poetry. A haiku is a short poem of three lines. The first line has five syllables, the second line has seven, and the last has five syllables.

Like the scroll, the haiku should express feelings about nature.
Here is an example:

> *Seashells on the beach*
> *Scattered on grains of white sand*
> *Have you traveled far?*

3. Japan has a long tradition of printing. Have your students create stamping prints the way Japanese schoolchildren do.

Materials Needed

- ✦ tempera paints or ink pad
- ✦ large piece of construction paper
- ✦ objects such as buttons, leaves, bottle caps, crumpled paper, string, cut-up potato, etc.

Have each student press an object onto the ink pad or paint and then print it on paper. They can repeat this shape many times to create a pattern, or they can compose a picture by using different objects on the same piece of paper.

4. Hokusai was an illustrator of *surimono*. These were small prints intended to be given to friends or family as New Year's greetings. Poets would create the words, and the artists would illustrate them. Have students work in pairs. One could be the poet; the other the artist. Suggest that children make cards to celebrate an event and give their *surimonos* as a gift.

5. The Tokaido Road was the most important route in ancient Japan, connecting the two important cities of Kyoto and Tokyo. There were many stops of interest along the way, including inns, tea houses, and beautiful sites. Students can make a map of a well-traveled road in their community. Mark the starting point and destination. Is the route straight or does it curve? Point out stops along the way. These could be interesting buildings, shops, restaurants, or places for recreation.

WINSLOW HOMER

1836–1910

Winslow Homer was a shy man who said very little about his life or his art. He believed his paintings spoke for him.

Homer grew up in Cambridge, Massachusetts, and led an active outdoor life. His love of the outdoors and nature was always part of his life and work.

His interest in art began very early. His mother was a skilled painter and she encouraged her young son to sketch

with pencil and crayons.

At 19, Homer became an apprentice in the shop of a Boston painter. But he hated having to draw and paint the way someone else wanted. He soon left to become an independent artist.

He began to do magazine illustrations, which were very successful. During the American Civil War, a magazine sent him to the battlefields to draw scenes of army life.

After the war, Homer began to paint what he knew best—life in the country. These paintings of children, women in hoop skirts, and farmers show us what country life in America was like in the 1860's and 1870's.

When Homer was about 40 years old, his interest changed. He began to paint the sea, and the men and women who earned their living from it.

In 1883, he settled on the rocky coast of Maine. There he built a studio where he lived alone. He spent his days observing nature and painting the beauty and power of the ocean.

Winslow Homer painted only what he knew. He never imitated other artists. The landscapes and people of America inspired his painting. He painted as he lived—with great energy, purpose, and independence.

1500 1600 1700 1800 1900 2000

SNAP THE WHIP

ARTIST: Winslow Homer **SIZE:** 12" x 20" **MEDIUM:** Oil on Canvas

A WALK THROUGH THE PAINTING

FIRST GLANCE

1. Can you guess what the red building was used for?

2. Why do you think the children are outdoors?

3. Close your eyes and imagine that you are outdoors with the other students. What sounds would you hear?

4. In what season of the year could this scene have taken place? Why?

CLOSER LOOK

✦ **What kind of game do you think the children are playing? Can you guess the rules of the game?**
The boys are playing snap the whip, which is also the title of the painting. Children hold hands, making a chain, and then run very fast. The first boys in line stop suddenly, yanking the others sideways. This causes those on the end to break the chain and fall.

✦ **How do we know that these boys are playing to win?**
Homer used body language to show us the physical stress of the game. Notice the pose of the boy who has fallen and the determination of the last boy to hold on.

✦ **Is snap the whip a team sport like basketball or baseball?**
The players in this game are not united in a common goal. It is more an individual effort to succeed. The last boy left standing would be declared the winner.

✦ **Can you think of any other sport that is a team effort?**

✦ **Can you think of other games that are individual efforts?**

✦ **If you had gone to school in the 19th century, how would you have dressed?**
The barefoot boys are probably saving their shoe leather for the long walk home. Sneakers did not exist. Boys had suspenders and buttons to hold up their pants. Zippers had not been invented. Most shirts had removable collars so they would stay clean longer. Almost everybody wore hats.

✦ **What are some ways the children could have gotten to school in the morning?**
Most children walked, but others were fortunate enough to be able to go on horseback. In some small towns, there was even a horse-drawn buggy, which would pick up students for a small fee.

✦ **Can you find the church steeple among the trees? What other objects are in the background?**

✦ **Winslow Homer painted scenes that came directly from his own experiences and observations. We recognize and understand the people and places in his paintings. This kind of art is called *realism*. *Snap the Whip* is a realistic story-telling painting.**

✦ **If the figures of the boys were removed from the painting what would be left?**
If the boys were not there, we would be left with a *landscape*. A landscape is a painting of nature. Throughout his life, Winslow Homer painted both landscapes and story-telling paintings.

INSIDE THE COUNTRY SCHOOL

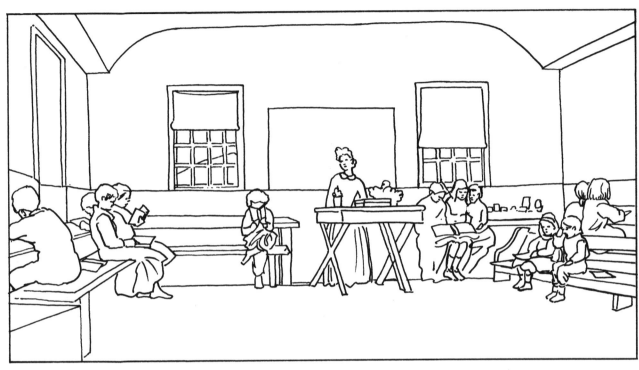

In 1871, Winslow Homer painted the inside of a country school.

In the space below, draw the inside of your classroom.

Name _____

SCHOOL DAYS

Here is an imaginary story about one of the boys in *Snap the Whip*. Make a drawing for each part of his day. Cut out the pages, put them in order and make a mini-book.

Hello! My name is James Robinson and I am ten years old. My sister Rebecca is only eight. We are both students at the red schoolhouse.

This morning it was cold and rainy. When I heard the rooster crow at first light, I wanted to go back to sleep. But mother made sure we got up to do our morning chores. There would be no breakfast until I carried in the wood for the stove. Rebecca had to get the water from the well.

We had to hurry. Miss Emily Brown, our teacher, rings the school bell at 8 o'clock and she sure gets angry if we are late. Last week I was late and Miss Emily had me stay in during recess. So today, Rebecca and I practically ran the two miles to school.

We were shivering from the cold and rain. Miss Emily had already lit the large wood-burning stove that stands in the middle of the room. The hanging oil lamp was also lit but it was still hard to see what I was writing on my slate. I kept making mistakes and had to wipe off the chalk with my shirt sleeve.

Name _____

Continued

SCHOOL DAYS

Our classroom is decorated with a picture of George Washington, the American flag, and a globe. All of us have a reader with stories, poems, and selections from the Bible. Sometimes we read out loud and sometimes we have to memorize pages. After reading, we open the *Common School Arithmetic Book*. Miss Emily makes us do "mental arithmetic." She gives us problems that we have to solve in our head.

We eat our lunch in the classroom and take a drink from the water pail with the large dipper. Finally it's time for recess. My favorite games are tag, hide-and-seek, and snap the whip. Rebecca likes to roll a hoop and jump rope.

I like my teacher very much, but if you break the rules you know you'll be punished. My friend, Benjamin, forgot to do his homework. He was kept in after school and had to clean the classroom.

At 4 o'clock school is over. Oh, I forgot to tell you that I won the spelling bee today. So Miss Emily gave me her own copy of *Treasure Island*. Maybe if Rebecca helps me clean the chicken coop, I'll have time to start reading it.

LOOKING FURTHER

1. Suggest that your class work in pairs. Half of the class can be children in the 20th century; the other half in the 19th century. The contemporary group writes a letter to one child in the painting describing a typical day in their classroom. The 19th-century children answer by telling about their school day.

2. A popular game of the time was Ante, Ante, Over the Shanty. If ball = *ante* and school = *shanty*, you can guess that the ball was thrown over the roof of the school. The child who found it won the game. Have your students make up a game that can be played outdoors. Describe the game and name it. Write the rules. Illustrate it and, if possible, play it.

3. Find one of Winslow Homer's paintings of the ocean. Compare the mood or feeling of the painting to *Snap the Whip*.

4. At the time of Winslow Homer, *The Common School Arithmetic Book* was found in classrooms all over America. It taught basic math skills—addition, subtraction, multiplication, and division. Its purpose was to enable students to solve everyday arithmetic problems in their head without the help of paper and pencil. There were no calculators or electronic cash registers in those days!

Here is a typical math problem from the 1800's: At the General Store a man bought 5 yards of muslin at 12 cents a yard; a wooden bucket for 50 cents, and 3 bags of barley at 6 cents a bag. How much does he owe the storekeeper? ($1.28)

Ask your students to make up a problem using objects and prices from the 1800's.

5. Winslow Homer painted people in motion. Think of a game or sport you enjoy playing or watching. For example, stand up and imagine you are kicking a soccer ball. Look at the position of your hands and legs. Feel the change in your arms and legs as you move. Now make a drawing of you—and your team—in action.

6. *The McGuffey Reader*, which was a popular textbook, had stories about people and animals. The stories taught a moral or lesson. Can you think of a children's story that has a moral? Can you write one?

PIERRE AUGUSTE RENOIR

1841–1919

Pierre Auguste Renoir was an artist who thought art should be pretty. He spent his life creating some of the happiest paintings ever made.

When Renoir was nine years old, his mother and sister took him to *the Louvre*, the great museum of art in Paris. The beautiful paintings and sculpture he saw there changed his life. From that time until he died at the age of 78, a paintbrush was never far from his hand.

When he was 13, he left school to work as a painter in a factory that made fine china. He saved enough money to go to art school. There he met other artists, including Claude Monet (moh-NEH) and Alfred Sisley. They became lifelong friends. Together, they helped develop the style called *Impressionism.*

The Impressionist artists did not try to make the things they painted look solid. Instead, they painted the effects of light. When you look at their paintings up close, you see only brush strokes and splashes of color. At first, this style seemed very strange to the people of Paris. The Impressionists had to rent their own hall to show their paintings. *Le Moulin de la Galette* was first shown at one of these exhibitions. But soon Renoir's rainbow-tinted portraits and landscapes brought him wealth and fame.

In Renoir's last years, he developed arthritis. His hands became so stiff that he could not hold his paintbrush. He bravely strapped a brush to his hand and continued to do what he loved. Before Renoir died, he was able to visit the Louvre and see his own paintings hanging there.

1500 1600 1700 1800 1900 2000

LE MOULIN DE LA GALETTE

ARTIST: Pierre Auguste Renoir **SIZE:** 4'3" x 5'8" **MEDIUM:** Oil on Canvas

A WALK THROUGH THE PAINTING

FIRST GLANCE

1. How does this painting make you feel?

2. What are the people in the painting doing?

3. Do you think the painting was done a long time ago or today?

4. What sounds would you hear if you were at Le Moulin de la Galette?

CLOSER LOOK

✦ **What does the title *Le Moulin de la Galette* mean?**
Moulin is a windmill; galette is a little cake dipped in wine. *Le Moulin de la Galette* was the name of a neighborhood dance hall built next to a windmill. Galettes were a popular snack served there.

✦ **Is the scene inside or outside? How can you tell?**
The patches of sunlight flickering through the trees indicate it is an outdoor scene. The chandeliers might give the appearance of being inside, but they are gas lights suspended on poles hung across the trees.

✦ **Who are these people?**
They are working people, shopkeepers, artists, and students. Renoir liked to paint ordinary people having fun.

✦ **In *Le Moulin de la Galette*, we feel as though we have walked by the dance hall and peeked in to see what was going on. Painting a scene as it was happening was important to Renoir. Each Sunday afternoon, he rolled his large canvas and took it to the dance hall. He wanted these people to look as natural as possible.**

✦ **Are any of the people looking at us?**
They seem unaware that they are being observed.

✦ **A painting that is not posed is called *candid*. Before Renoir's time most artists posed their models. Renoir's art surprised the people of Paris because they were used to a scene that was planned and painted in the artist's studio.**

✦ **Renoir and his friends were part of a group of artists who painted in France in the 1870's. They were called *Impressionists*. They often painted**

outdoors.They wanted to show the light of the sun exactly as our eyes see it.

✦ **Can you find the seated man with his back toward us? He seems to have round patches on his jacket and head. Do you think the patches were really there? Why did Renoir paint them?**

Renoir was interested in reflected light. The sun shining through the leaves on the trees form these patches.

✦ **Can you find other patches of reflected light?**

The blonde hair of the young girl and the straw hats of the men show the dappled sunlight.

✦ **Can you find the brush strokes on the chair? Can you find brush strokes on other objects?**

Renoir and the Impressionists did not blend their colors. The brush strokes add to the excitement and the freshness of the painting.

✦ **Does your eye seem to move around the painting? Why?**

The swirling dancers and the circular hats form a rhythm within the painting.

✦ **Look at the diagonal formed by the back of the bench in the foreground. It divides the painting. Which side of the painting has more action? Which side is blurry? Is Renoir showing us movement by blurring the outlines of his figures?**

✦ **Look at the diagonal once more. Which people are closest to you? Compare these people with the people in the back of the dance floor. Did Renoir paint them differently?**

The people in the foreground are much clearer and more detailed. We can even see the design on the lady's hat. There is very little detail on the people in the background. Impressionists often eliminated detail.

✦ **Compare Bruegel's *The Peasant Dance* with *Le Moulin de la Galette*. How are they similar? How are they different?**

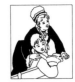

Name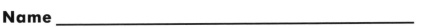

AN APPLE A DAY

How did the Impressionists see the everyday objects in their world? Try this experiment and find out.

1. Bring a red apple into your class. Draw the apple and color it red.

2. Now look at the side of the apple that is nearest to the light. Is this a lighter color? Draw and color your apple again. This time, make one side darker than the other. This is called *shading.*

3. Does your apple have a highlight? A *highlight* is a spot of bright light on an object. The highlight on your apple is a reflection of the light that is shining on it. You can add a highlight by putting a small stroke of white on your apple. Or you can let the white paper show through in one spot. Draw your apple with a highlight—and shading.

4. Now put your apple on a piece of colored paper. Does the color of the paper reflect on the apple? Color the apple again, adding the rainbow of colors you see. Impressionists like Renoir believed that reflected color was as important as the actual color of an object.

Name _____

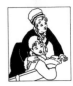

YESTERDAY AND TODAY

150 years ago, when Renoir was a boy, life was very different from today. Below are two columns. The first shows what was popular in Paris when Renoir was a boy. In the boxes on the right, sketch something popular today.

RENOIR'S WORLD

DANCES
Mazurka, Polka,
Can-can

ENTERTAINMENT
Theatre, Concerts,
Picnics,
Dance Halls,
Boating

TRANSPORTATION
Horse and Buggy,
Railroad Trains

COMMUNICATIONS
Writing Letters,
Telegraph

TODAY

DANCES

ENTERTAINMENT

TRANSPORTATION

COMMUNICATIONS

44

DANCE HALL CUT-UPS

Jacqueline and Jacques want to go to the dance hall, too. Color and cut out their outfits and dress them for the occasion. You might want to act out what they will say and do when they get there.

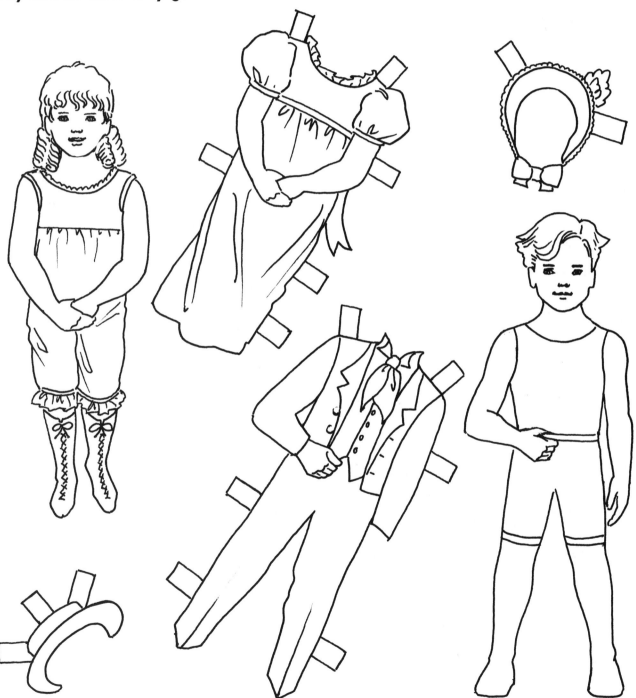

LOOKING FURTHER

1. Renoir liked to have fun and he often painted his friends relaxing. Have the students color or paint a picture of their friends playing. Suggest that they do it in the style of the Impressionists. (They should copy the colors they see, using separate brush strokes or crayon marks.)

2. Have the class look outdoors on a sunny day. Must the sky be only blue or the grass only green? Suggest that the students make a picture of nature (real or imagined) with the rainbow colors that are in the sunlight. Using pastels, paint, or crayons, they can create their own Impressionist work of art. Their colors might suggest the season of their pictures.

3. Renoir's son, Jean Renoir, wrote a biography about his famous father. To get the facts, he interviewed his father to find out how he worked. Have students interview interesting older relatives, asking questions about their childhood, schooling, work, and hobbies. Then ask them to write biographical sketches of their relatives. They may want to illustrate their biographies with photographs or their own drawings.

4. Renoir's artist friends included Monet, Sisley, Pissarro, Manet, Degas, and Cezanne. Suggest that students find the paintings of these artists in the library. Have each student write a report about his or her favorite.

5. The Impressionists painted in France. They particularly painted in Paris, on the River Seine, and in the sunny south of France on the Mediterranean Sea. On a map, have the students find France. Have them locate Paris, the Seine, and the Mediterranean Sea. See if they can find the little towns of Nice and Cagnes (not Cannes) where Renoir worked.

6. Get to know a rainbow. Have students name the three primary colors and the three complementary colors. Then have them experiment with mixing two primary colors. Examples: red and yellow, blue and red, blue and yellow.

7. Hold a prism up to the sunlight. Ask the children what colors they see. Ask them where they have seen these colors before. (In a rainbow.)

8. There is a difference between *looking* and *seeing*. On the way to school each day, students look at many things, but how often do they closely *observe* a tree or the front door to a house? Have students observe one thing closely on the way to school. Have them sketch it and/or describe it. Have them observe the same thing on the way home and sketch it again. Did it change?

MARY CASSATT

1844–1926

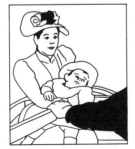

Mary Cassatt's family was shocked that she wanted to become an artist. Her father said, "I would almost rather see you dead."

At the time of the Civil War in America, most proper young ladies became wives and mothers. It was not respectable for a girl to have a career. Mary Cassatt was determined to have one.

When she was 15, Mary Cassatt applied to the

Pennsylvania Academy of Fine Arts, which was considered modern because it admitted women. She worked in separate women's classes, drawing large plaster casts and sculptures. Unlike the men, women were not allowed to copy from live models. More than ever, Cassatt wanted to paint. She convinced her father to allow her to study in Europe.

In Paris, Cassatt received permission to copy paintings of the masters at the Louvre. She traveled to see the works of the world's great artists. She began to paint portraits of young women and children in her own sensitive style.

At that time in Paris, all serious art was judged by an important group of artists called *the Salon*. The Salon accepted several of Mary Cassatt's paintings. This was a huge honor for any artist, but especially for an American woman!

Edgar Degas was one of a rebel group of French artists who were called *Impressionists*. When he saw Mary Cassatt's extraordinary paintings, he invited her to join his group. She knew that the Salon disliked the Impressionists' style of painting. But she was eager to try new techniques. With the same courage that led her to become an artist, she joined the Impressionists. Said Mary, "I began to live!"

Mary Cassatt created hundreds of paintings of children—each one of them different. The paintings are as fresh and lively as the children who live in them.

1500 1600 1700 1800 1900 2000

THE BOATING PARTY

ARTIST: Mary Cassatt **SIZE:** 2' 11½" x 3' 10⅛" **MEDIUM:** Oil on Canvas

A WALK THROUGH THE PAINTING

FIRST GLANCE

1. Is this a painting of today or was it painted a while ago?

2. What words would you use to describe the mood of this painting?

3. What would you title the painting?

CLOSER LOOK

✦ **Who are the people in the painting? Do you think they are related?**
The mother and child look as though they belong together. The man may be a rower (oarsman) or part of the family.

✦ **What color is water? How does water get its color?**
Water is clear, but its color comes from what might be in the water and from the reflection of the sky.

✦ **In this painting, what color do you think the sky might be? How can you tell?**
There is just a bit of sky, but it must be blue since the water is so blue.

✦ **Is the sun shining? How can you tell?**
Although you can't see the sun, you can see the sunlight. It is shining on the oars, on the curve of the boat, and on half of the child's face.

✦ **Where do you think Mary Cassatt might have been standing when she painted this scene?**
There are many possibilities. Perhaps she was on a dock above the boat looking down at the people. She may be in another rowboat. She could even be inside the boat behind the oarsman.

✦ **Why do you think Mary Cassatt did not paint the front of the boat?**
The artist might have cut off the front of the boat to make us feel part of the scene. We are almost in the boat behind the rower. She allows us to imagine the rest of the scene.

✦ **Cutting out part of the picture is called *cropping*. What else in the painting is cropped?**
The sail, the oar, the rower, and the background.

✦ **Look for the background. Why is it such a narrow strip?**
Most of the painting is startling close to us. The boat is in the *foreground*. We can only glimpse a very small section of the *background*.

✦ **What is the biggest and boldest shape in the painting?**
The oarsman's large body seems to fill the space in the foreground.

✦ **Even though the oarsman is so large, where do our eyes focus? Why?**
The mother and child get our attention because they are looking directly at us. The diagonal line of the oar, the man's arm, and even the curve of the boat also make our eyes focus on the mother and child. And the light colors of the mother and child stand out more clearly against the blue water than do the dark colors of the oarsman.

✦ **The oarsman is so large that he threatens to take over the painting. But he doesn't. What balances the painting?**
Mary Cassatt painted large curved ribbons of blue, white, yellow, and green color to keep the painting (and the boat) from tipping over.

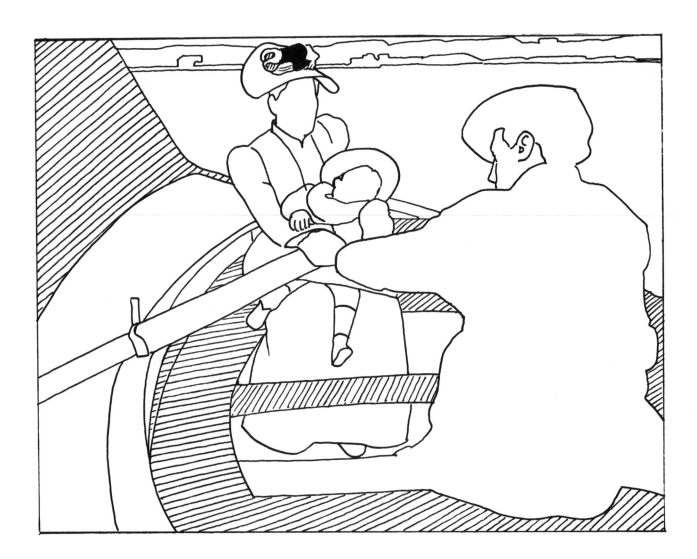

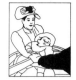

Name _____

ROW YOUR BOAT ASHORE

Mary Cassatt painted very little background in her painting. What if you could move away from the boat? The farther away you get, the more foreground and background you would see.

Have fun completing this picture. Are there other boats in the water? Perhaps there are swimmers, ducks, or lily pads. Would you like to show a reflection? Is anyone else in the boat?

ALL IN THE FAMILY

Mary Cassatt painted many portraits of mothers and children. The mothers and children from two of her paintings are shown below. Color the portraits and cut them out. Mount each person on a stick. Then match each child with a parent. Create a dialogue—or little play—about what they might say to each other.

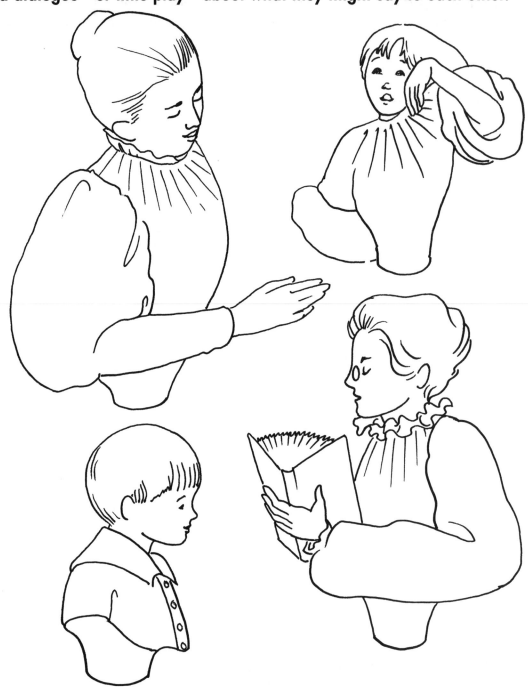

Name _____

SPECIAL DELIVERY

The United States honored Mary Cassatt twice with commemorative stamps. In 1966, *The Boating Party* was printed as a five-cent stamp. Then, 22 years later, the Postal Service created a stamp with Mary Cassatt's portrait on it.

Pick a well-known person you admire. Create a stamp in his or her honor. Make sure you show the country's name and the value of the stamp. You might also want to include the name of the person as part of your design.

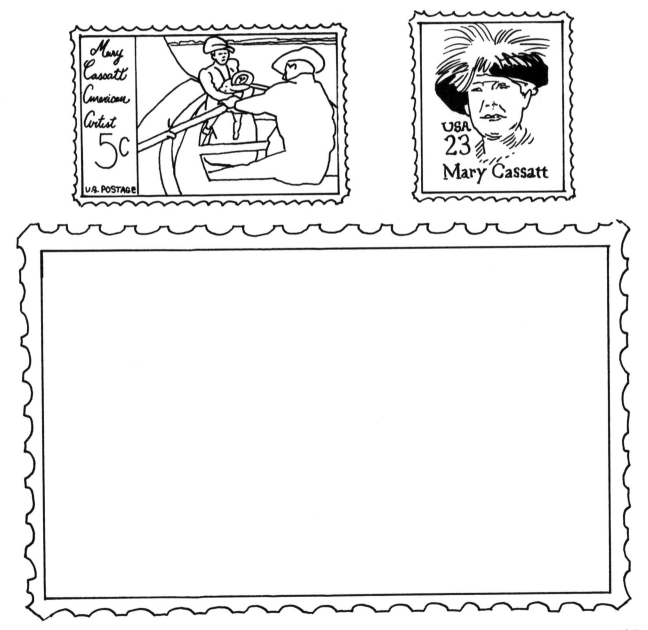

LOOKING FURTHER

1. Mary Cassatt was born at a time when women were not always free to choose a career. Many other women had to overcome great obstacles to become successful. Have each student select a woman who reached her goal despite overwhelming odds. Have students write reports about these women, detailing why they think they succeeded.

2. Mary Cassatt wrote many letters to her family and friends in America to tell them about her life in Europe. Try to find pen-pals for your students from a different country—or from another state. Have them describe their school and activities in letters to their pen-pals.

3. Have the students list jobs/careers open to women today that were not options for Mary Cassatt. Also have them list important jobs that men now have that used to be done only by women.

4. Mary Cassatt loved to travel. She was born in Philadelphia, Pennsylvania, but she traveled to Paris, Heidelberg, Florence, Rome, Madrid, London, and Cairo. Have the students draw a map and trace her journey to these cities, all famous for their art. In what countries are they found?

5. In 1892, Mary Cassatt was *commissioned* to paint a huge mural for the Women's Building at the Chicago World's Fair. She decided to show "Modern Women." Have a group of classmates plan a mural. They might want to show careers of the future, school in the 21st century, the role of women today, tomorrow's travel, etc.

6. Mary Cassatt was very friendly with several other Impressionist artists. Edgar Degas was her great friend, and so were Camille Pissarro, Edouard Manet, Pierre Auguste Renoir, and Claude Monet. Suggest that your students look for paintings by these other Impressionists and compare their works with those of Mary Cassatt.

7. Mary Cassatt's favorite subjects for her paintings were the people in her family. Perhaps your students would like to sketch portraits of one or more of their relatives. Suggest that they try to draw the relatives when they are not posing so that they look natural.

PABLO PICASSO

1881–1973

Pablo Picasso is probably the most famous artist of the 20th century. He was born in Malaga, Spain. People who knew him as a child said he could draw before he could speak. His father, an artist, was amazed at his son's enormous talent. He gave all his brushes and paints to Picasso when the boy was 13.

As a teenager, Picasso broke away from traditional art. He moved to Paris, France, and lived in a cold studio with

little food. There, he produced over 200 paintings of beggars, workers, and children who were also poor and lonely. Over and over, he used the color blue to paint what he saw and felt about their sad lives. Later, these works were called Picasso's Blue Period.

Next, Picasso started to paint the acrobats and clowns who performed at the circus. He used warmer, pink tones that became known as his Rose Period.

When Picasso was 25, he painted *The Ladies of Avignon*, his first painting in the style called *Cubism*. In Cubist paintings, objects are twisted and spread out so you see them from all sides at once.

Then Picasso starting painting portraits that looked like jigsaw puzzles with jumbled pieces. But if you look at them carefully, you can see how they fit together to make a human face.

Picasso's next surprise was to paste bits of paper, cloth, buttons, or string onto his paintings. He created an art form called *collage*, from the French word for paste.

When his children were born, Picasso painted some of his most beautiful realistic portraits. He wanted to show the sense of wonder and playfulness of young children. He painted mothers very large, as little children would see them. He made a statue by sticking together his son's toy car and other objects. It was the first time anyone had made a sculpture this way.

Even after he became famous, Picasso worked on his art every day. He was still working the day he died, at the age of 92. He once said, "Creation is the only thing that interests me."

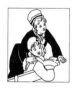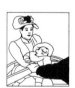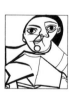

1500 1600 1700 1800 1900 2000

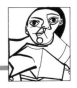

FIRST STEPS

ARTIST: Pablo Picasso **SIZE:** 4' 3¼" x 3' 2¼" **MEDIUM:** Oil on Canvas

A WALK THROUGH THE PAINTING

FIRST GLANCE

1. How many figures did Picasso place in this painting?

2. Are they related to one another?

3. How did your mother appear to you when you were very little and had to look up at her? Was her face and body much larger than yours?

CLOSER LOOK

✦ Can you remember what it was like to be a very young child? A baby?

✦ Picasso painted as though he knew and felt what a small child knew and felt, and he often painted through the eyes of that small child. He realized that even when we are all grown up, we still have memories of our own childhood.

✦ What is the child in the painting learning to do?
The child is taking his very first steps. For the first time, he is reaching out and exploring the world around him. Learning to walk is one of the most important and difficult tasks that a child can accomplish. Picasso tried to capture the wonder and novelty of that event.

✦ Can you remember learning a difficult task? How did you feel? Is it possible to have more than one feeling at a time?
Children taking their first steps can be nervous and frightened. Perhaps they will fall or get lost. Perhaps they will fail completely and not be able to walk alone. At the same time, they might experience a feeling of joy and pride in their new-found independence.

✦ Can you read the emotions Picasso has painted on the child's face? Did you notice that the two sides of the face are different? Cover the right side of the face and just look at the left side. What do you think the child is feeling?
The face seems almost joyful with a smile and a wide open eye. You can see the child's delight in his new accomplishment.

✦ Now cover the left side of the face and look at the right side. What do you think the child is feeling?
The ear is too high and the eye and cheek are distorted. It is as though the child's fears are being revealed.

✦ What information does Picasso give us about the mother by making her so large?

The mother's huge body encircles the child. She is there to protect and teach. All her energy and love seem to be directed at the child. Her face looks downward with concern and tenderness.

✦ **Picasso often painted mother and child in a realistic way. Why do you think he chose to paint in a different style for this particular picture?**
Picasso knew when he painted the figures in *First Steps* that "nobody looks like that." But he thought he was telling more about the inner feelings of the mother and child by changing, distorting, and rearranging their figures.

✦ **What is *Cubism?***
Look at the desk in your classroom. Picasso could have painted it in a realistic way and we would all recognize what it was. But Picasso knew what the back of the desk looked like. He could picture the sides of the desk and the underside of the desk. He could imagine the desk from above or from any other angle. Therefore he could tell more about the desk if he flattened it and painted all its parts at the same time. It would be as though he were walking around it and continually drawing its many shapes.

✦ **With Cubism, Picasso was no longer concerned about painting objects exactly as they appeared in real life. He could rearrange any object into its separate parts as it suited him. What could be done with a desk, for example, could also be done with a human face or a body.**

Name

TAKE APART ART

Look at the painting *First Steps*. Then cut out the pieces of this jigsaw puzzle. Fit them together to look like the painting. Glue the pieces to a sheet of paper and color the puzzle.

59

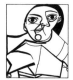

Name _____

ABOUT FACE

Picasso painted many portraits. Here are some of them. If they could speak, what would each say?

Name _____

SHAPE UP!

Shapes are everywhere. Cubist artists often look at objects and notice that they are made of different geometric shapes.

A *circle* can be many things—such as a clock or your head. Draw a few things that are round in the box on the left.

How many things that are shaped like a *rectangle* can you draw in the box? For example, you might draw a desktop or a notebook.

Draw some things shaped like a *triangle*, such as a mountain peak or an ice-cream cone.

A soup can has the shape of a *cylinder*. In the box, draw some objects that are this shape.

Draw a picture using just one shape.

Draw a picture using all four shapes.

LOOKING FURTHER

1. Picasso's Cubist portraits often showed more than one feeling or mood. Can you find some other paintings by Picasso that show different moods? Discuss some situations when your students were both happy and sad at the same time. For example, their birthday party is taking place when their best friend has chicken pox. Have the students draw a Cubist style portrait dividing the face or entire body to express happy/sad, serious/silly, noisy/quiet, wild/gentle, etc.

2. Picasso created many *still life* paintings. Assemble three items of different shapes in your classroom. (Examples: globe, books, plant.) Ask the children to gather around the still life with their drawing paper and draw the shapes of the things they see. Like Picasso, they can change what they see to add what they know or feel about the object. Have them color their pictures and compare their different points of view.

3. Picasso once found a broken bicycle. He retrieved the seat and handlebars and fastened them to a wall. He had created a bull. Have your students create a sculpture from found objects. Suggest that they recycle clean unbreakable garbage such as plastic foam, buttons, boxes, plastic containers, small paper cups, etc. They can fasten the sculpture together with masking tape, glue, or wire. Have them name their junk sculpture and list the materials they used.

4. Picasso's art was so diverse that it paralleled the art of the 20th century. Divide the class into groups and have them research and report on Picasso's Blue Period, Rose Period, Cubist paintings, collage, and sculpture. Each group can create a work of art in the style of Picasso.

5. Picasso's own houses often gave him ideas for his art. He filled each house he lived in with art, and when there was no more room, he moved. (Some of the homes he left became museums.) Have students make a diorama or a drawing redesigning their whole house or just one room. They can make furniture that looks like sculpture, and decorate their walls as they please.

6. Picasso loved animals. Birds, dogs, monkeys, and fanciful creatures populate his art. Have students create a Picasso zoo. They can make the animals—real or imagined—from construction paper and found objects.

7. *First Steps* is a painting about a new experience. Have students tell or write a story about facing a new experience, for example: the first day of school, the first night sleeping away from home, the first day of camp, the first time skiing, etc.

8. If your students enjoyed assembling the jigsaw puzzle, have them make their own. They can make a shape drawing. Have them start with something real like a person, animal, or bowl of fruit. Have them draw the shapes that they see and color them. Have students cut them out like puzzles and see if their friends can reassemble them.

ROMARE BEARDEN

1911–1988

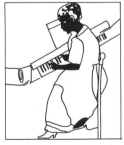

Romare Bearden was a painter, poet, songwriter, and even a baseball player. (He pitched for the Boston Tigers, an all-black team.) But he became famous for his work in *collage*—pasting bits of fabric and paper on a surface.

In 1987, President Reagan awarded Bearden the National Medal of Art. His works are displayed in many major museums throughout America. Bearden became successful when he was young and stayed

successful for the rest of his life. But he always had time to help young artists.

Many people thought of Bearden as the artist who painted the black experience, especially in the South. Black culture certainly played a large part in his art. But Bearden believed that his paintings described all of America, not only black America.

He was born in Charlotte, North Carolina, in 1911, but lived most of his life in New York City's Harlem and in Pittsburgh. He attended Boston University and New York University and planned to go to medical school. But when he started drawing and designing cartoons for a local black newspaper, he discovered that his future lay in art, not medicine.

In his collages, Romare Bearden pieced together memories of his American heritage. He was a master at creating the sounds, feelings, and colors of his Harlem youth and his Southern childhood.

 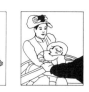 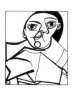 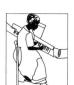

1500 1600 1700 1800 1900 2000

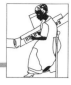

THE PIANO LESSON

ARTIST: Romare Bearden **SIZE:** 3'4" x 2'7" **MEDIUM:** Oil and Collage

A WALK THROUGH THE PAINTING

FIRST GLANCE

1. What are the people in the painting doing?

2. In what room is this activity taking place?

3. How many objects in the room can you identify?

CLOSER LOOK

✦ **Is this a scene from long ago? How can you tell?**
Although Bearden painted *The Piano Lesson* in 1983, this work, like many others he painted, recalls personal memories of his childhood.

✦ **Have you ever seen clothes like those worn by the teacher and her student? Where?**
Little details like the embroidered petticoat (underslip) peeking out from the girl's dress above her old-fashioned shoe add to the feeling that the artist is recalling a scene from the past.

✦ **What objects in the parlor tell us this is the house of a music teacher?**
Alongside the upright piano is a large music stand. A triangular *metronome* (an instrument that sets the speed of the music) sits on top of the piano.

✦ **How does the artist show us the teacher's feelings about her pupil?**
From the way the teacher's body is bent over her student, you can tell she takes her job very seriously. Her hand is pointing to the music on the piano. It is possible she is correcting the young girl's playing.

✦ **Can you guess what kind of music the girl is playing?**
In discussing this painting, Bearden said, "No jazz was allowed in her parlor." This teacher made sure her students played only classical music.

✦ **How many rooms can you see?**
The green curtains behind the piano and in front of the standing cabinet act as a room divider. There are two rooms.

✦ **Can you discover how the rooms are lit?**
A lamp hangs from the ceiling and a smaller lamp is placed on the table on the right. Both these objects, plus many others in the painting, are examples of collage.

✦ **What is *collage?***
Collage is the French word for pasting. *The Piano Lesson* combines pasted fabric, photos,

colored paper, and magazine illustrations with paints. For example, the shape of the hanging lamp was cut from a magazine illustration of an old Chinese vase and then pasted onto the painting.

◆ **Romare Bearden once said, "It'll be grand when I can get the colors to walk about the picture like free men...." Let's look at the color yellow. Can you follow it as it walks around the painting?**

◆ **Can you trace the path of the brick-red color as it moves around the painting?**

◆ **Besides color, what else helps move our eyes around the painting?**
Shapes and lines are also repeated in different parts of the painting and help to *balance* the picture.

◆ **What is balance?**
What if you went on a seesaw with someone who weighed more than you? It wouldn't be much fun. It would be better if the person on the other side weighed about what you weigh. Then you could go up and down very easily—you would be balanced. The sides of many paintings need to be balanced, too.

◆ **How did Bearden balance his painting?**
He did it with color and shapes.

◆ **Compare the colors in the two sides of the painting. How are they alike? How are they different? Do you think they are balanced?**

◆ **Now compare the shapes. What shapes do you see on each side? Do you think they fit together?**

◆ **By repeating shapes and colors, Bearden has created a painting where everything is balanced and the separate parts are in harmony.**

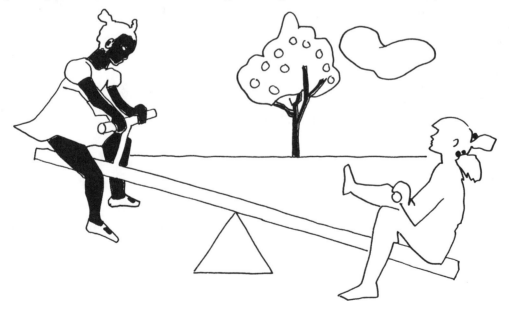

Name _____

COLOR ME COOL

Bearden was both an artist and a musician. Just as some sounds can be "cool" in music, some colors can be "cool" as well. Color the boxes below in cool colors.

Did you choose blue, green, purple, black, or gray?

Sounds and colors can also be "warm." Color these boxes in warm colors.

Did you choose yellow, red, pink, orange, or brown?

Like different kinds of music, different colors can change our mood. Below are two shape diagrams of *The Piano Lesson*.

Color Box 1 using only cool colors.

Color Box 2 using only warm colors.

LET'S DRAW A POEM

Below is the first verse of a poem that Romare Bearden wrote. In both his poetry and his paintings, he often described his memories of the past.

Sometimes I remember my grandfather's house
A garden with tiger lilies, my grandmother
Waving a white apron to passing trains
On that trestle across the day road.

Let's make a *calligram*. A calligram is a poem in which the words themselves form a design.

Design your calligram in the space below. You might want to start with: (Your name) likes . . . If you like baseball, your words might be arranged in the shape of a ball. If you like cats, your words can form the shape of a cat. There is no limit to the kinds of designs you can create.

ROMARE BEARDEN LIKED COLORS AND SHAPES JAZZ TRAINS GRANDPARENTS PEOPLE MEMORIES COLLAGE BLUES PAINT-BRUSHES CANVAS YOUNG ARTISTS IMAGES MICHAELANGELO HARLEM POETRY.

Name _____

GETTING IN SHAPE

Shapes also have a mood and rhythm.

Can you draw a nervous shape?

Can you draw an exploding shape?

Can you draw a cheerful shape?

Now draw a slow shape.

Color each of your shapes. Cut them out. Rearrange them in the box below. You might want to have your shapes *overlap*. Overlapping is putting one shape on top of part of another shape. When you are pleased with your arrangement, paste the shapes down. With your crayon, fill in the space around your shapes. You have designed a collage.

LOOKING FURTHER

1. August Wilson, a famous playwright, wrote *The Piano Lesson* after he had seen Romare Bearden's painting. He imagined how the family first got the piano, and the people who played it. He even guessed the kind of music that was played on it. Have the students write a short play about what having and playing a piano might have meant to the people in the painting or the rest of the family.

2. Romare Bearden often painted to music. He liked jazz and classical music. Play a recording of a piece of music. Ask the students: Is the sound soft or loud? What colors and shapes do the sounds suggest? Have the students make a drawing to the music they hear. You might have them fold their paper in half and play two different kinds of music. Compare the colors, lines, and shapes on each side.

3. Bearden's collages are often associated with a place where he lived or visited. Have students recall a place that is special to them. It could be the beach, grandma's house, or a vacation spot. Using magazines and photographs, students can cut out and assemble pictures that remind them of that place. Suggest that they arrange them with their own drawings to make a collage.

4. Bearden painted memories of his childhood. Have the children recall their earliest memories and draw them. Remind them that memories don't have to look real. They may appear larger or brighter than they do in real life.

5. *The Piano Lesson* is about a child learning a new skill. Have your students recall a time when they learned something new. It could be a new sport or a game. Have them write a short story describing how they felt before the first lesson, while they were learning, and after they had accomplished the task.

6. Romare Bearden's collages often dealt with social issues and events of the day. He felt very strongly about equality for all people. Have your students select one topic that concerns them. It could be pollution, global warming, the economy, etc. Have them collect magazine illustrations, newspaper headlines, fabric, and other found material, and arrange these items into a collage.

7. Both Picasso and Bearden painted *The Three Musicians*. See if you can find copies in the library. Students might then draw their own musicians—a rock band, a jazz combo, etc. Have them use hot or cool colors that suggest the kind of music the band is playing.

SUGGESTED CULMINATING ACTIVITIES

1. Transform your classroom into a museum. Have your students submit their own works of art in a variety of styles. Divide the class into the following committees:

 A. FRAMERS: Responsible for preparing the artwork for display.

 B. CURATORS: Responsible for selecting and displaying the art.

 C. CATALOGUERS: Responsible for creating a catalog of the exhibition, which includes the name of each artist and the title of the work.

 D. DOCENTS: Responsible for guiding guests through the exhibition.

 You may have a gala opening of your exhibit. Invite parents and other classes to attend.

2. Now that your students have "read," or interpreted eight works of art, have them make some comparisons. You might have already compared the dancers in *The Peasant Dance* and *Le Moulin de la Galette*. You might also:

 A. Compare the mother and child in *The Boating Party* to the mother and child in Picasso's *First Steps*.

 B. Compare the use of flat shapes in *The Piano Lesson* and *First Steps*.

 C. Compare other objects—such as trees and faces—that appear in several of the paintings.

 D. Compare these eight masterpieces with other paintings hanging in your school.

3. Visit a local art gallery or museum.

4. Have students make dioramas of their favorite paintings.

5. Each biography features a time line. Have your students make a chart that would show parallel events that occurred in the world. For example, they could mark advances in science, technology, music, exploration, etc.

6. Students can bring art to life by creating a tableau or pantomime of the paintings. They might dress as the people in the painting and assume the poses. If they wish, they might prepare a dialogue and explain who they are.

BIBLIOGRAPHY

The following books contain information on the eight artists presented in *Meet the Masterpieces*. They are recommended as resources for your students.

Beardsley, John. *First Impressions, Pablo Picasso.* Harry N. Abrams, New York, 1991.

De Trevino, Elizabeth B. *I, Juan de Pareja.* Farrar, Straus & Giroux, New York, 1987. (A Newberry Medal winner about the artist who was Velazquez's assistant.)

Glubok, Shirley. *The Art of Japan.* Macmillan, New York, 1965.

Goodenough, Simon. *The Renaissance: The Living Past.* Arco, New York, 1979.

Kalman, Bobbi. *Early Schools.* Crabtree, New York, 1982.

Loeper, John J. *Going to School in 1876.* Atheneum, New York, 1984.

Meyer, Susan E. *First Impressions, Mary Cassatt.* Harry N. Abrams, New York, 1990.

Ripley, Elizabeth. *Hokusai, A Biography.* J.B. Lippincott, Philadelphia and New York, 1968.

Ripley, Elizabeth. *Velazquez, A Biography.* J.B. Lippincott, Philadelphia and New York, 1965.

Ripley, Elizabeth. *Winslow Homer, A Biography.* J.B. Lippincott, Philadelphia and New York, 1963.

Rodari, Florian. *A Weekend With Picasso.* Rizzoli International, New York, 1991.

Scheader, Catherine. *They Found a Way: Mary Cassatt.* Children's Press, Chicago, 1977.

Skira-Venturi, Rosabianca. *A Weekend With Renoir.* Rizzoli International, New York, 1991.

Sullivan, Charles. ed. *Children Of Promise: African-American Literature and Art for Young People.* Harry N. Abrams, New York, 1991.